TRACING AND COLORING
HEARTFELT HOLIDAYS
BY NAMI NAKAMURA
An Adult Tracing & Coloring Book for the Holidays

"Tracing and Coloring Heartfelt Holidays" is a new concept adult coloring book that will take coloring to a whole new level. Tap into your inner artist by tracing the tinted illustrations and then color them in. You will get the deep satisfaction of drawing while having guidance. In the process, you will develop drawing skills, hand/eye coordination and pen control through the exercise of tracing.

Drawing is a skill that many admire but few learn. Tracing is a simple way to draw with confidence. As with any areas of mastery, "practice makes perfect". The more you practice, the more you master. There are many elements of the drawings that are repeated, such as circles, stars, stripes, patterns and more. This is the framework for building these drawing skills.

Enjoy this new adventure into drawing and coloring. Have a creative heartfelt holiday season.

With Blessing,
Nami Nakamura

Tracing and Coloring Heartfelt Holidays
by Nami Nakamura
©2017 Nami Nakamura

All rights reserved. No part of this publication may be reproduced, distributed or transmitted in any form or by any means, including photocopying, recording or other electronic, mechanical or manual methods without prior written permission of the author, except in the context of reviews or promotion.

How to use this book:

You may begin on any page and in any segment. Start by using a black fine tip pen to trace the illustration. Take your time to trace the lines. Allow the lines to guide your hand and relax in the process.

After tracing the illustration, use colored pencils, alcohol markers, water-based markers or watercolor pencils to color in the image. Make sure your coloring tools work well with your drawing pen so one doesn't smear the other. You may want to test before coloring.

The pages are printed on one side to prevent ink transference but it is recommended that you put a sheet of paper or cardstock behind the page you are coloring to minimize this. High quality coloring tools are recommended for best results.

Who This Book is for:

This book is for anyone wanting to take their coloring skills to a whole new level by adding drawing to this popular hobby. This is also perfect for homeschoolers and kids wanting to learn to draw, adults who want to draw. and those wanting to find a new therapeutic hobby. It can also benefit those that need tools to help build hand/eye control through tracing.

Note from the Artist:

The artwork is hand drawn and has imperfect and charming qualities that set it apart from commercial and computer generated art. Enjoy the uniqueness of this style as you trace and color by expressing your creativity.

You can find more of Nami's art and products on **denamistudio.com**.